One Cycle of My Journey

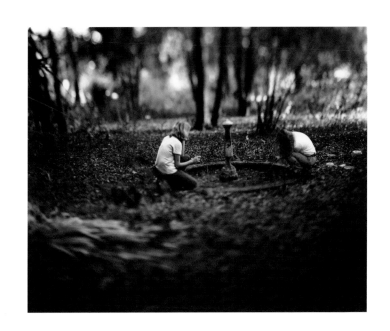

I use images as a poet uses words or a musican uses notes.

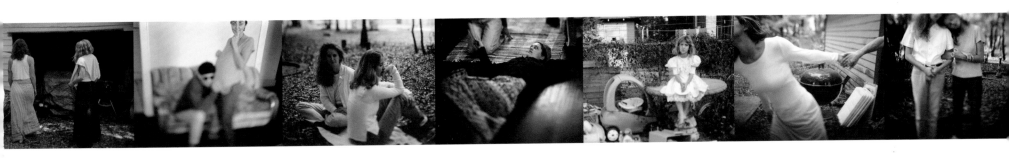

While one is beautiful on its own, it is enhanced by joining others.

First Edition
2002

Library of Congress Cataloging-in-Publication Data

Cohen, Abigail.
One Cycle of My Journey/[photographs by Abigail Cohen] —1st ed.
p. cm.
ISBN 0-9722515-0-2
1. Photography. 2. Women's Studies. 3. Cohen, Abigail, 1973-2000 I. Title

2002111469

Light Warriors Press

Designed by Michael Goesele
Creative Direction by Miwa Nishio and Meredith Marlay

Printed and bound in China by Imago, USA

This book is dedicated to the irrepressible memory of Abigail Cohen whose piercing perceptions of people are revealed in this collection of photographs.

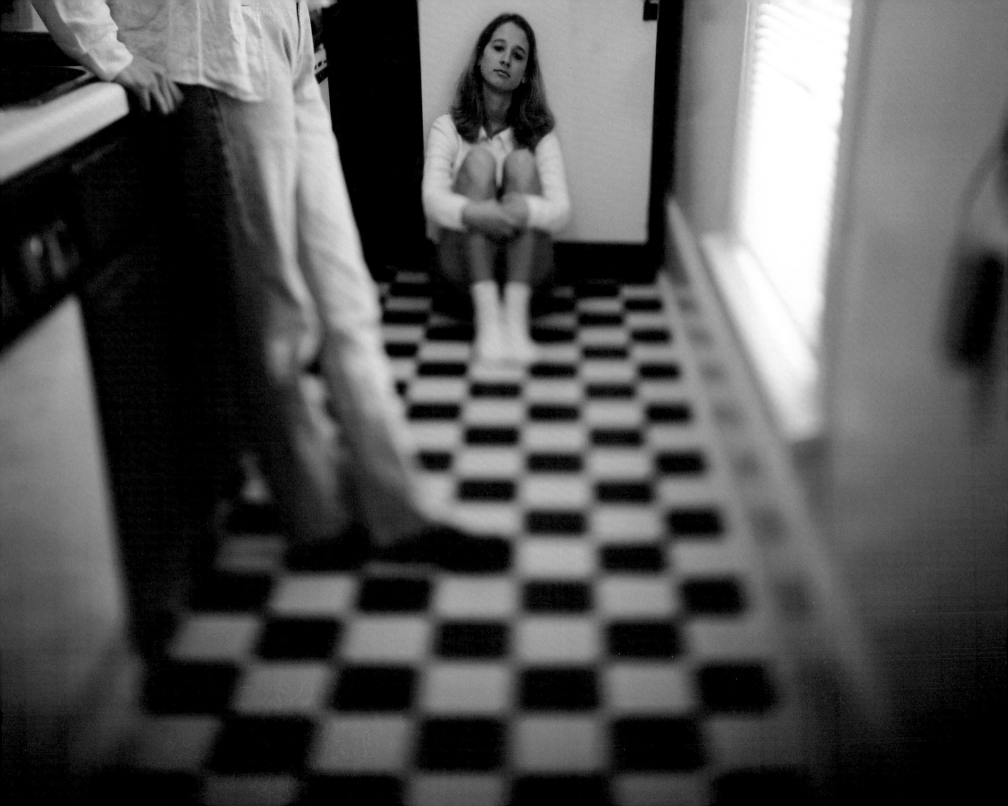

What can I say about Abigail?

8

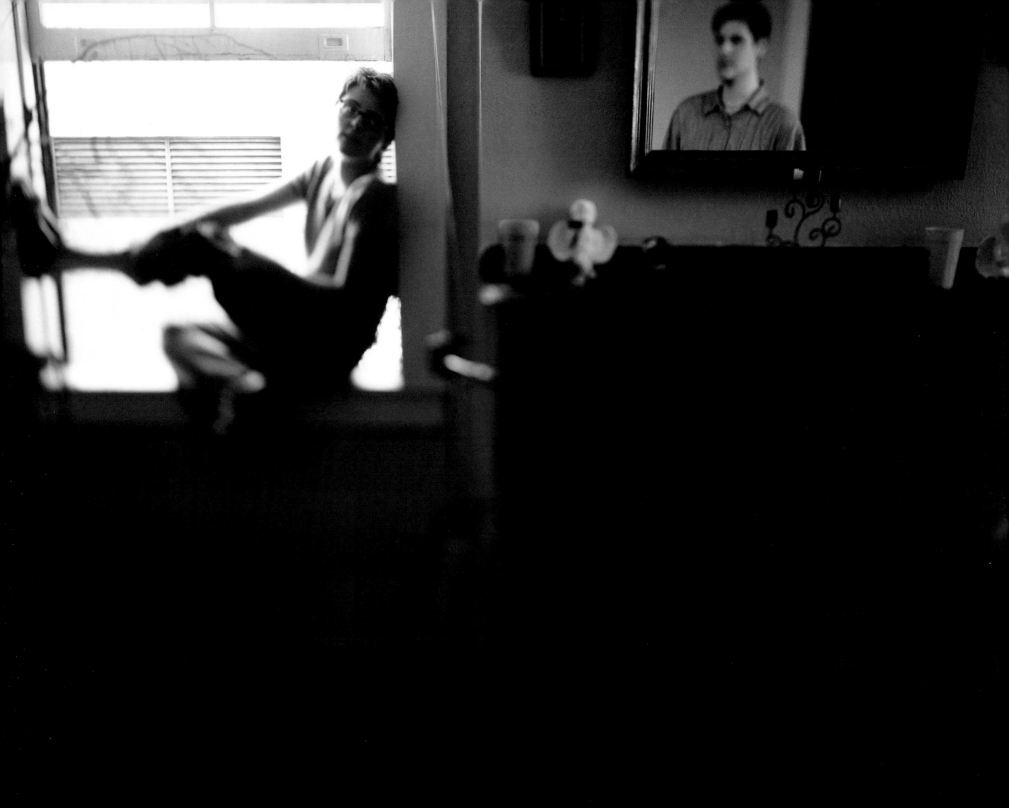

I'm interested in freeing

the photographic image

from it's supposed limitations

— Abigail Cohen

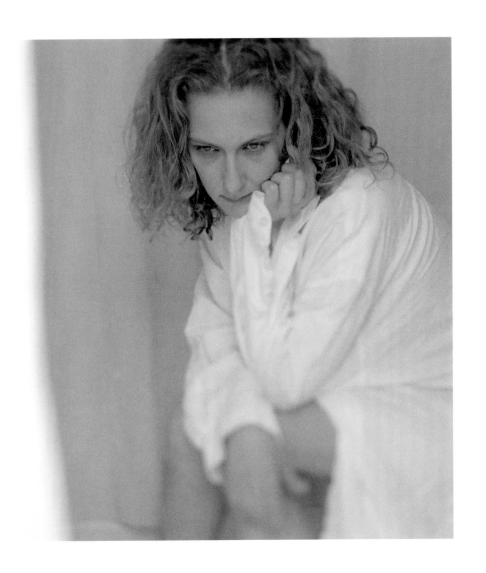

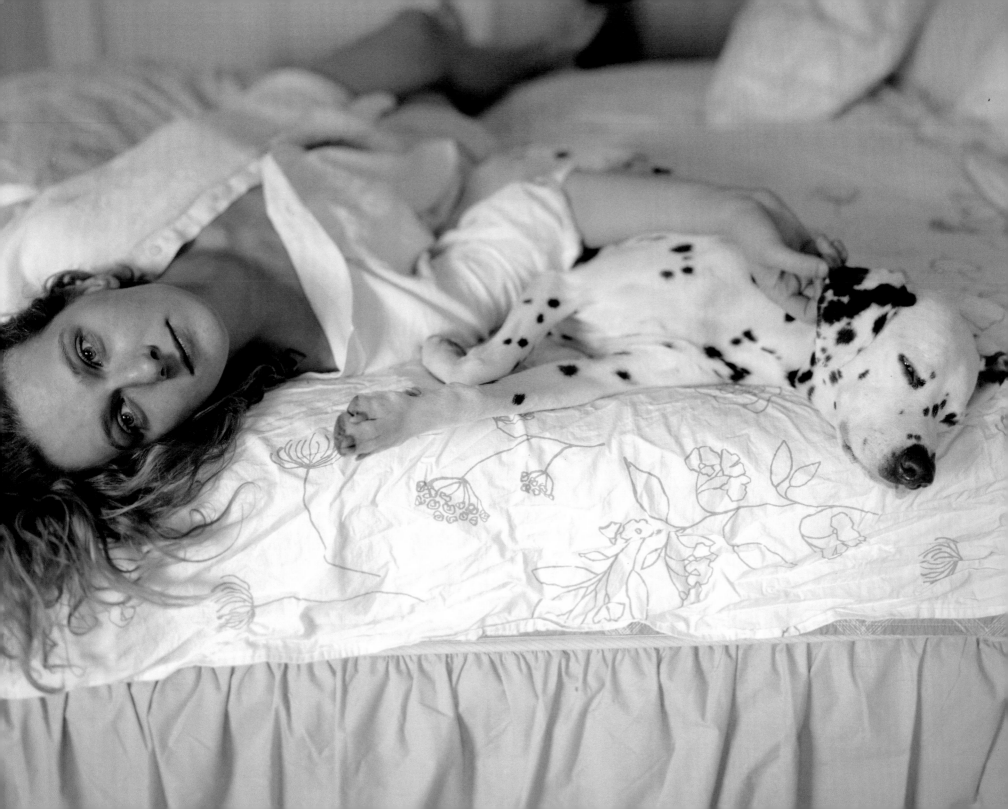

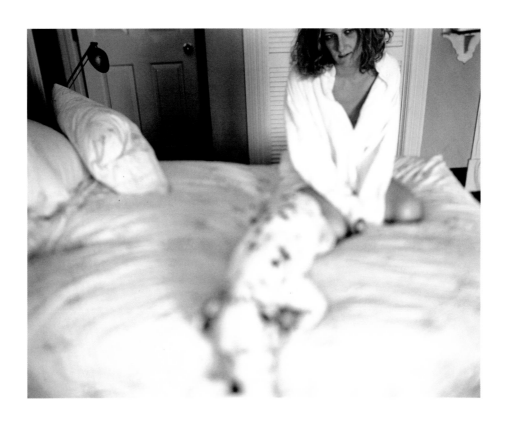

Using a plastic camera and available light,

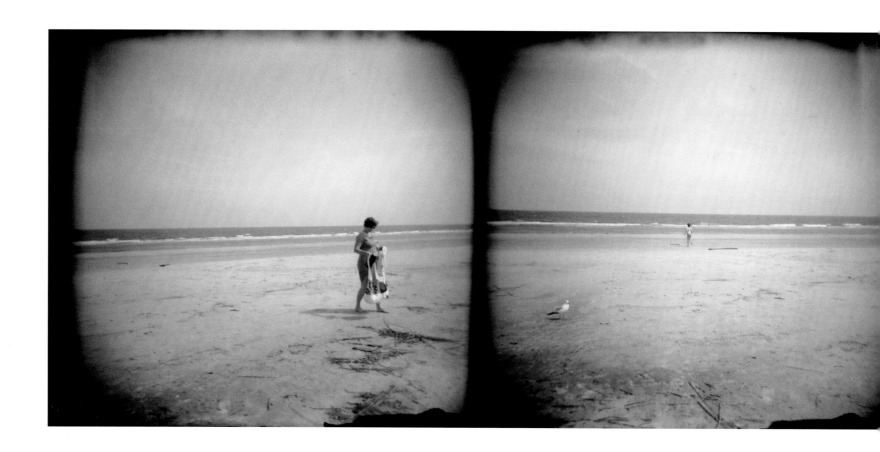

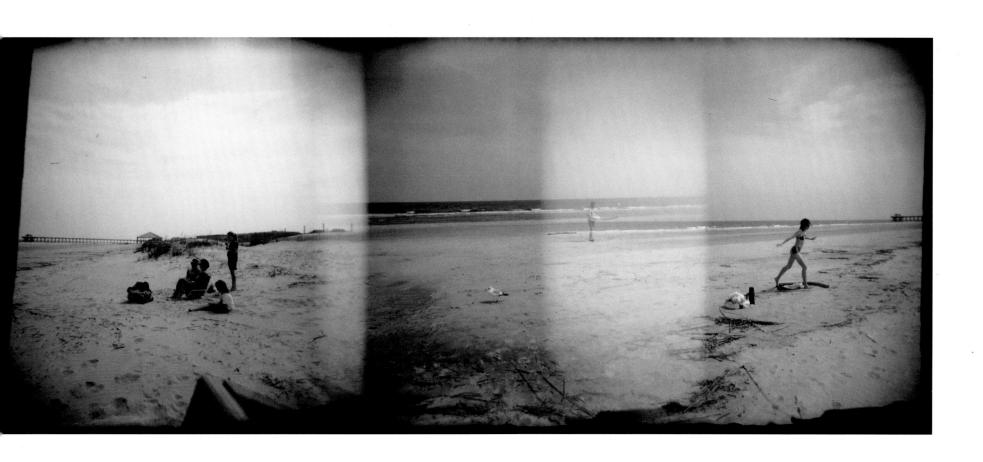

she isolated moments of timeless simplicity

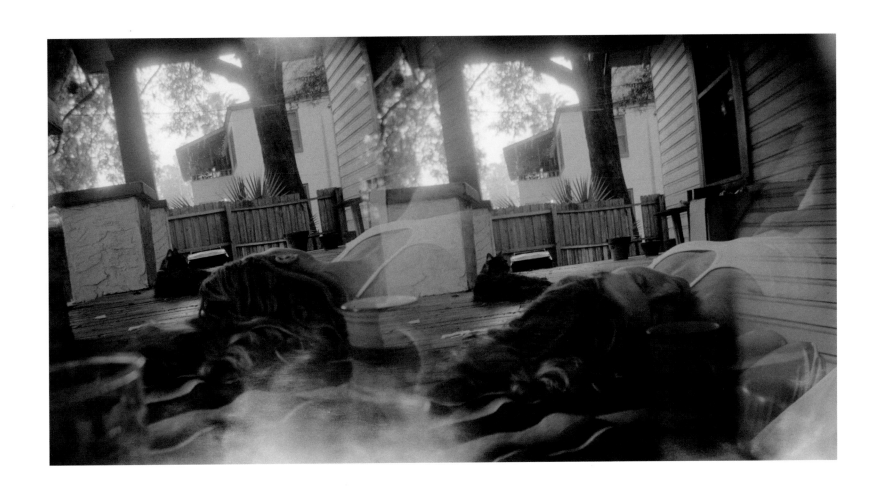

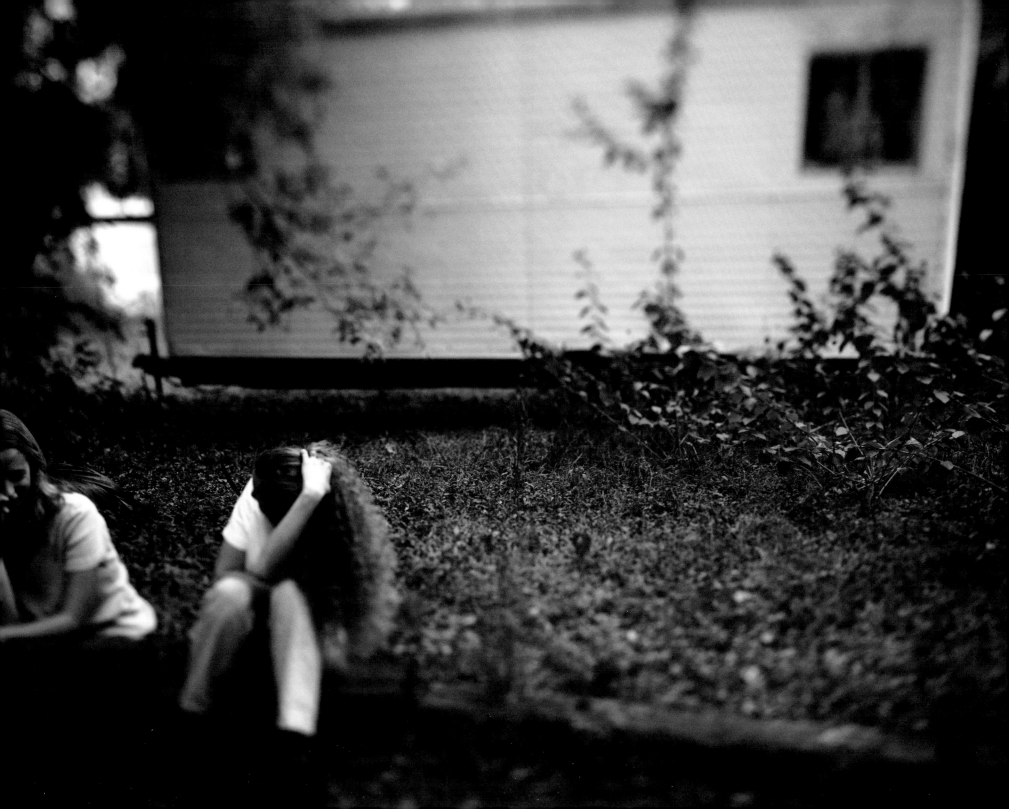

life was really very simple and straightforward

There is a balance of all things:

a balance

of intimacy and tension

of chaos and fludity

of mystery and awareness.

This all reflects my philosophy of life.

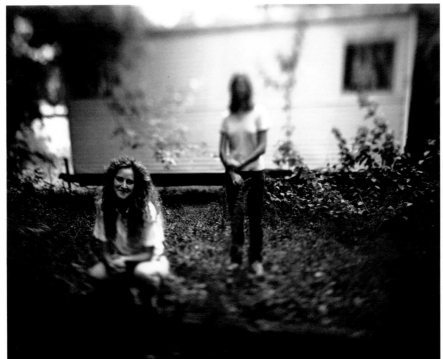

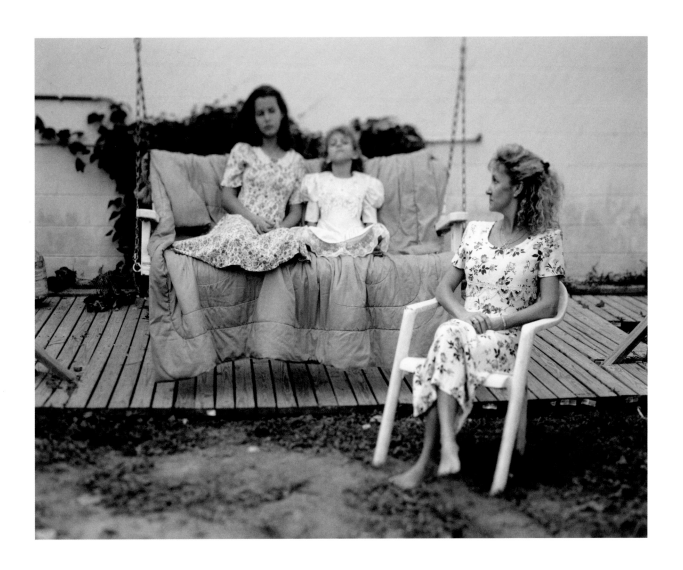

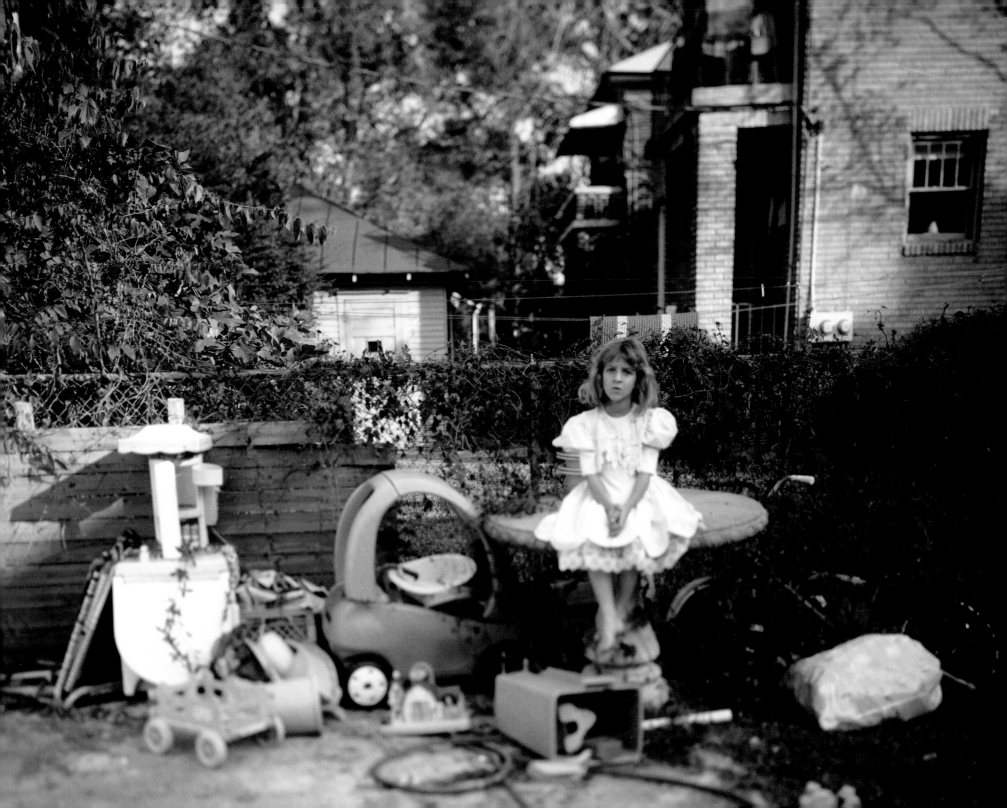

a short story with no beginning or end

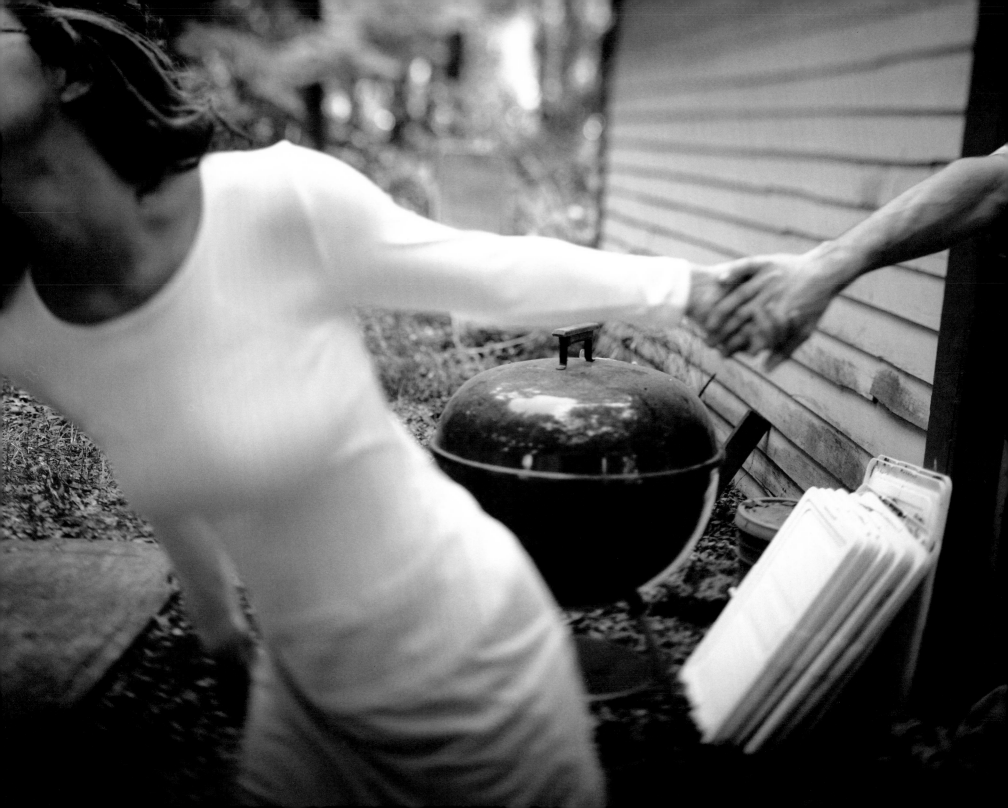

I see life as both romantic

and terrifying

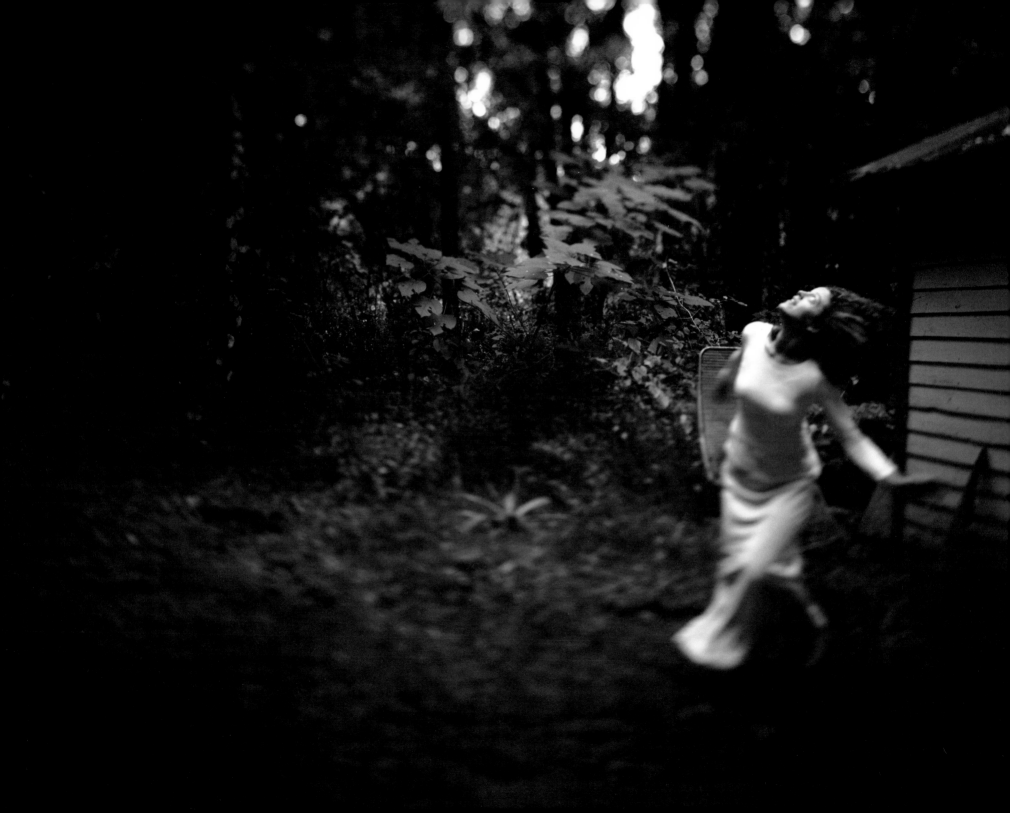

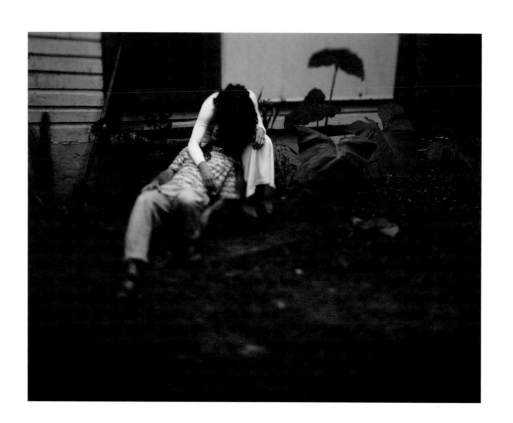

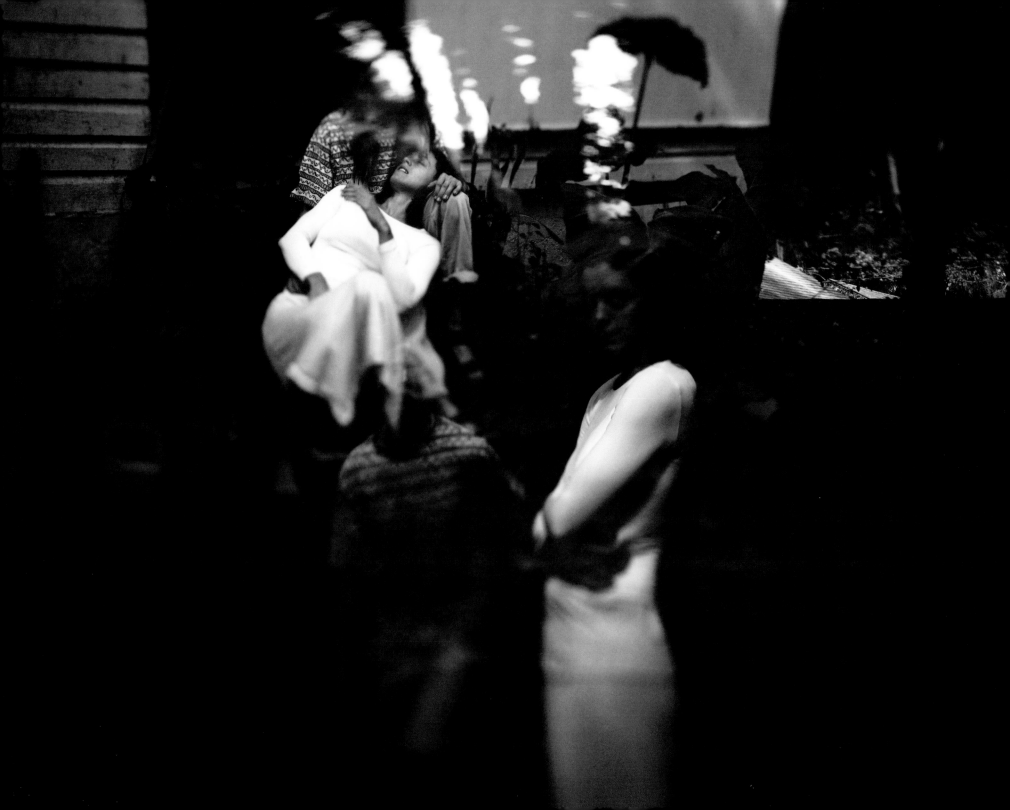

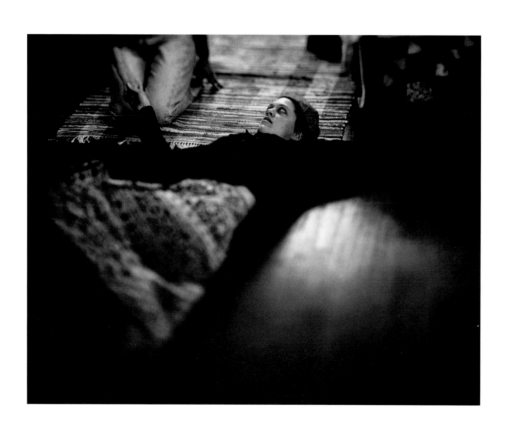

Mysterious edges

that define people's relationships with each other,

their surrounding and circumstances

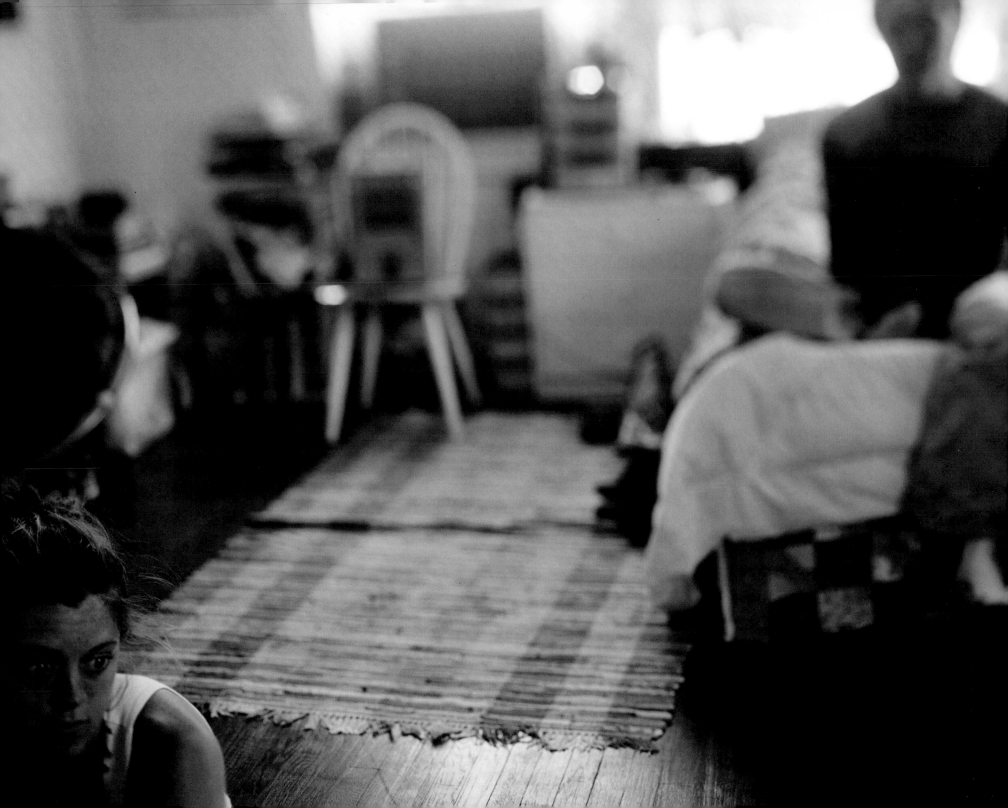

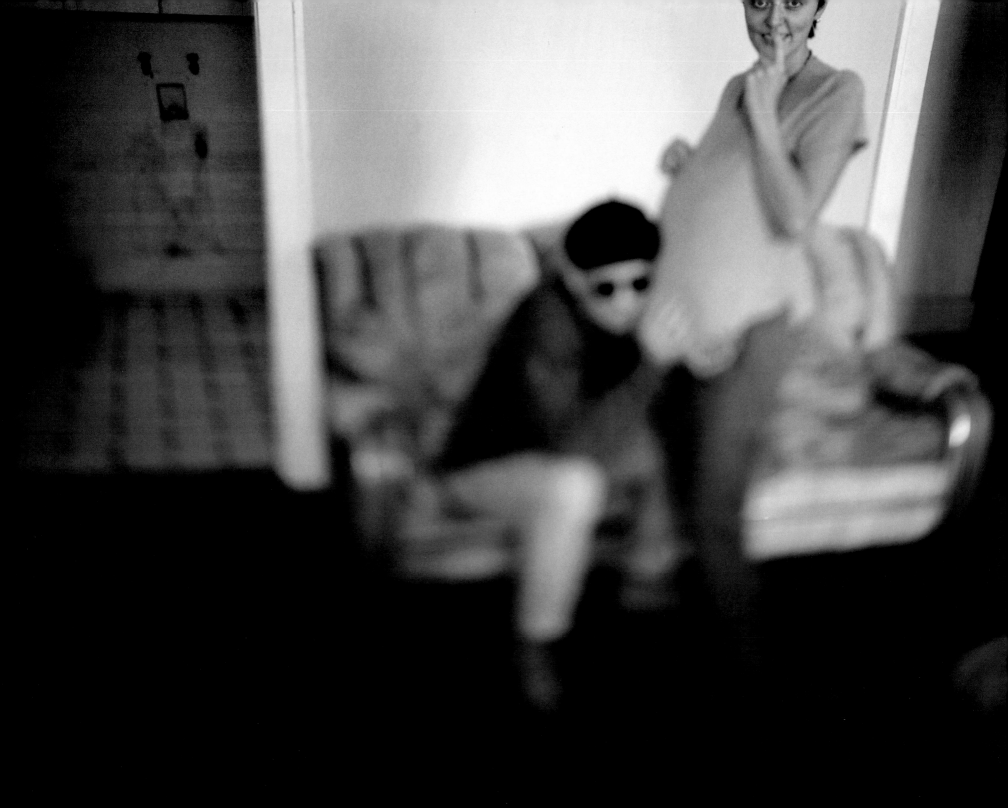

our own places of memory

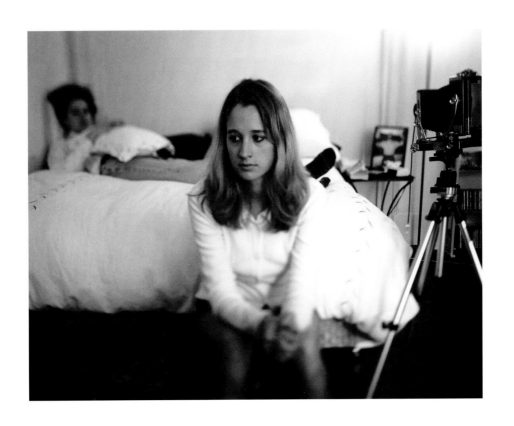

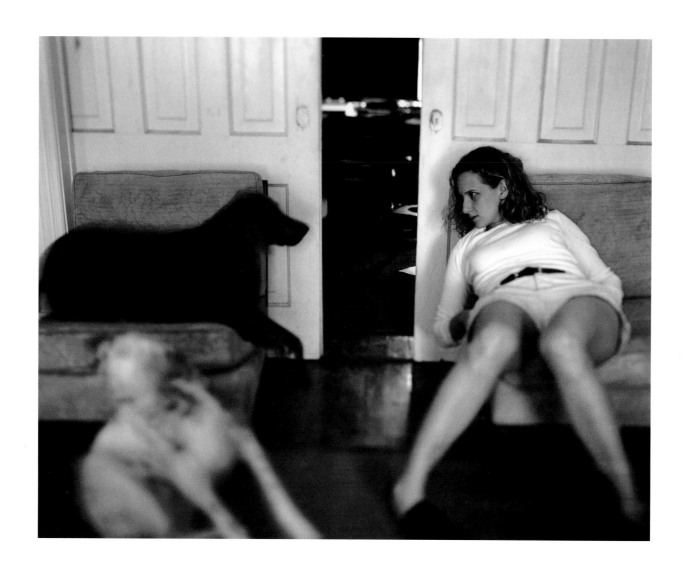

We are sometimes alone,
 sometimes with others
sometimes dissected

sometimes overlapping, repeating, blank…

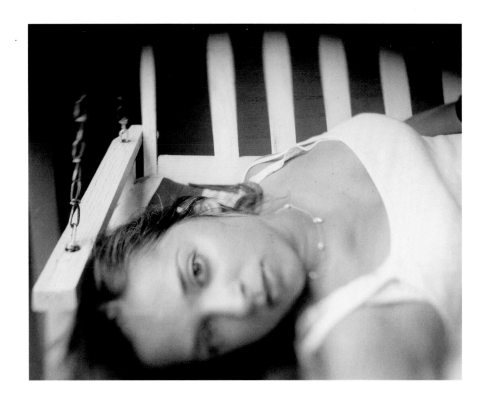

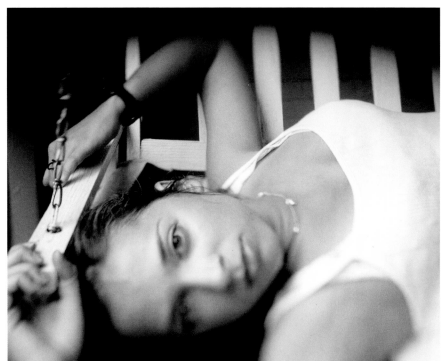

50

One beautiful fall afternoon,

Abigail took photographs of my daughter Kaya and me.

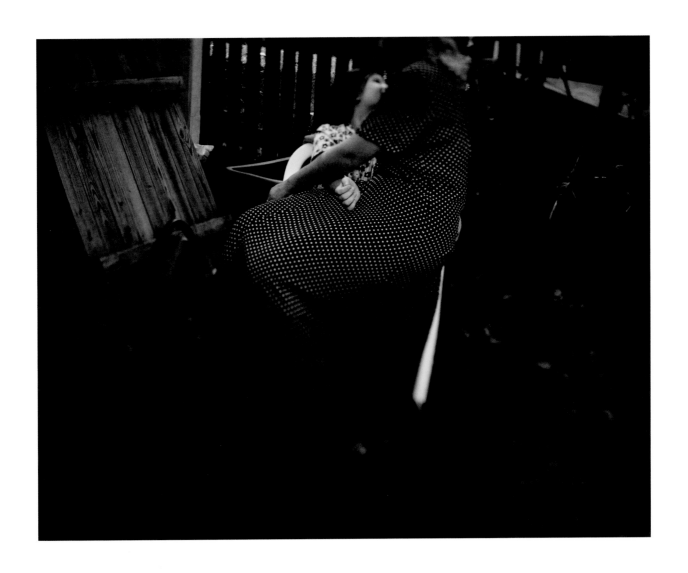

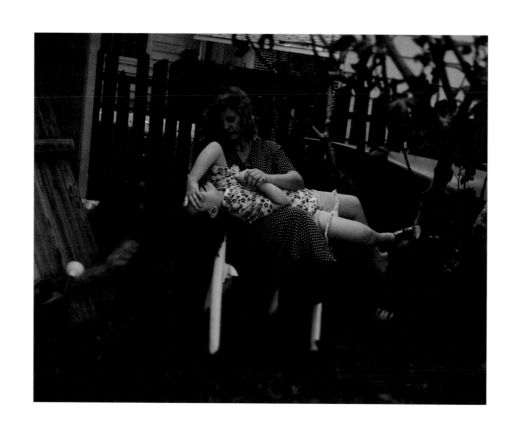

54

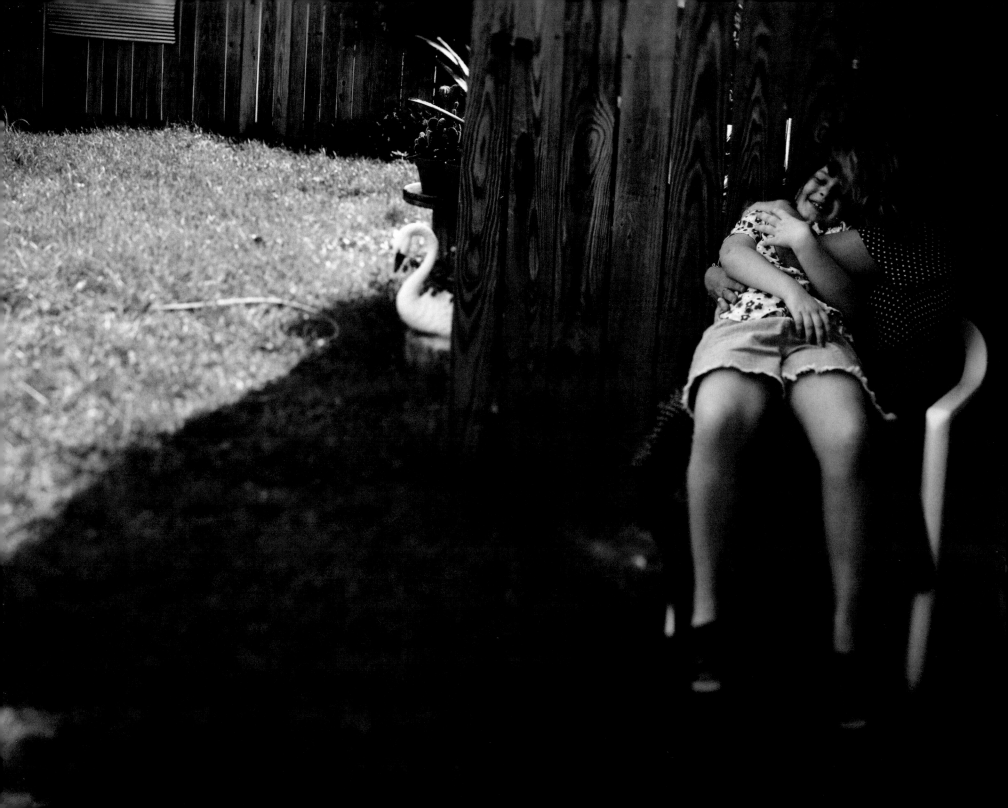

she showed me beauty in all its complexity

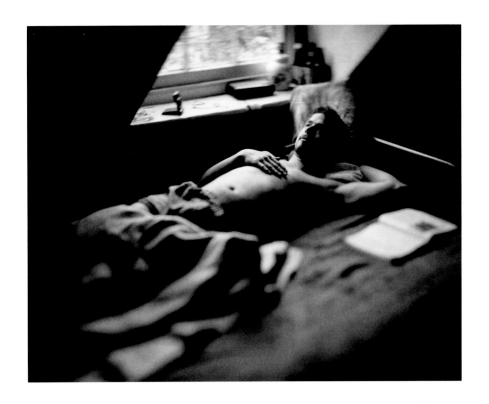

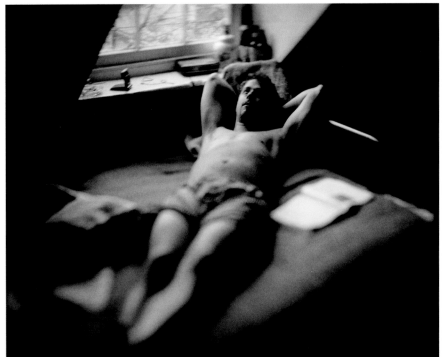

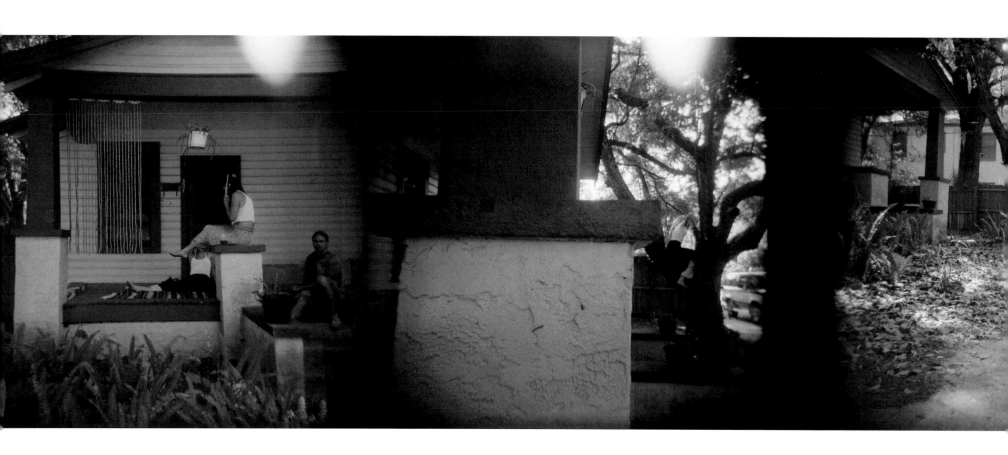

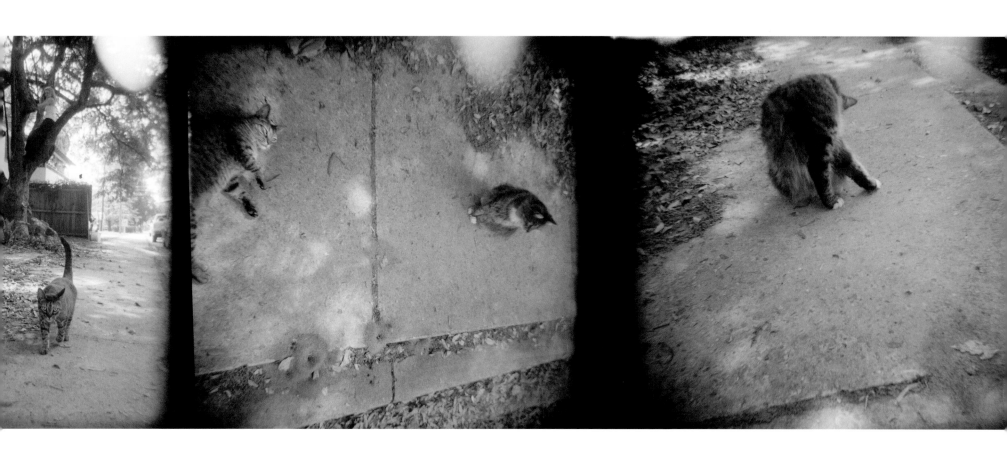

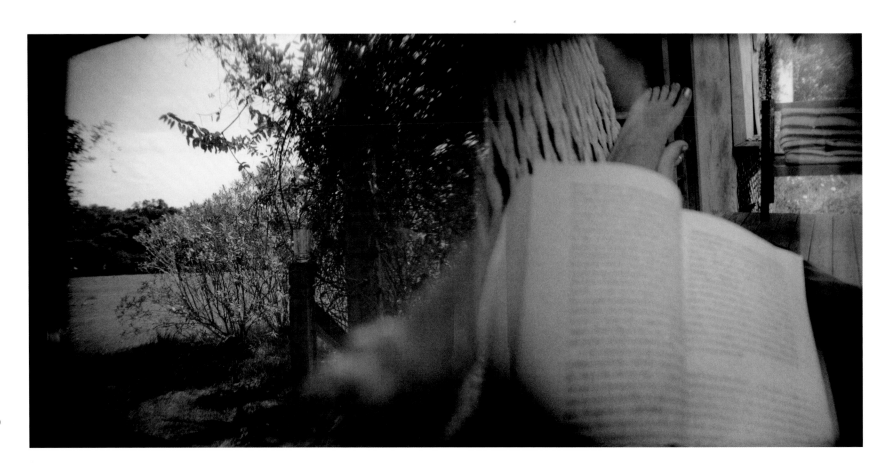

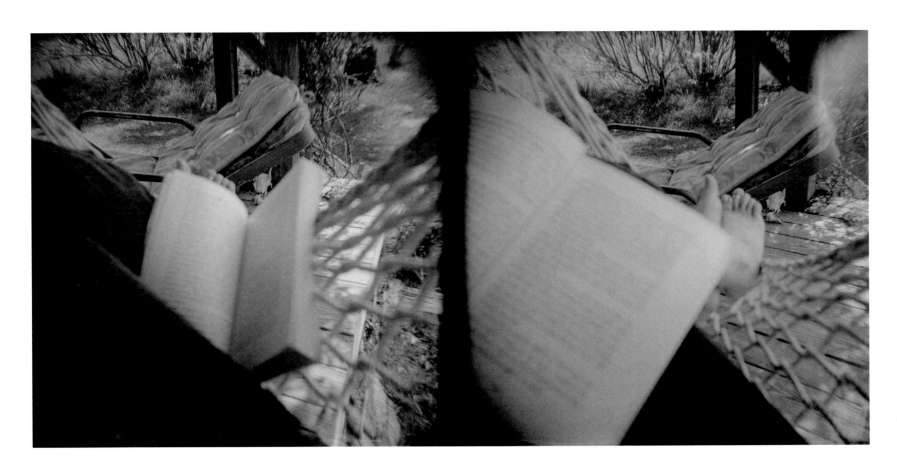

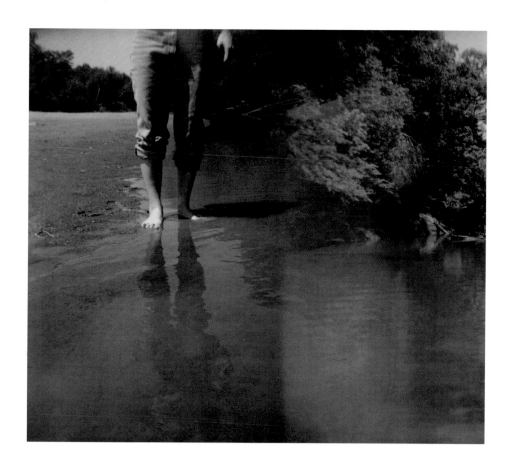

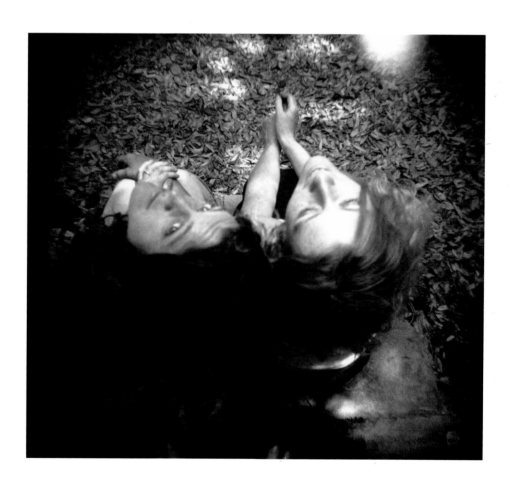

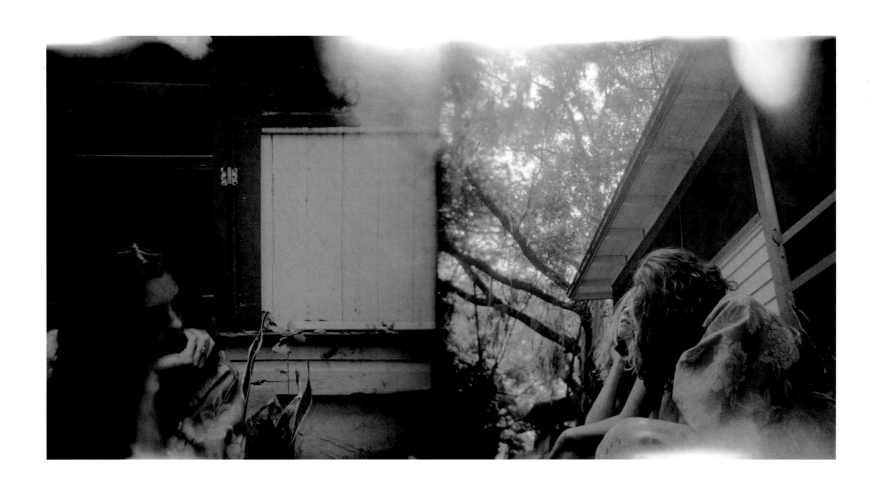

65

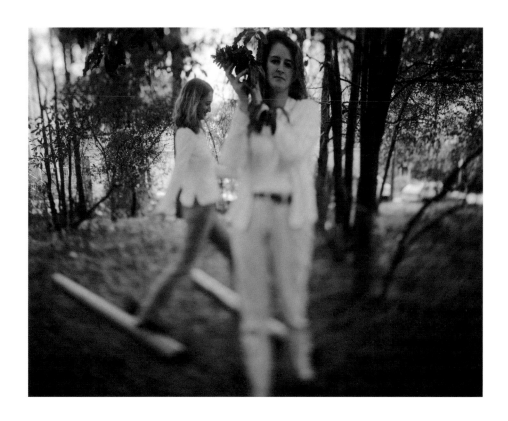

I can't separate my memories of

getting to know you

from getting to know myself

At each turn of my life

you were there turning yourself.

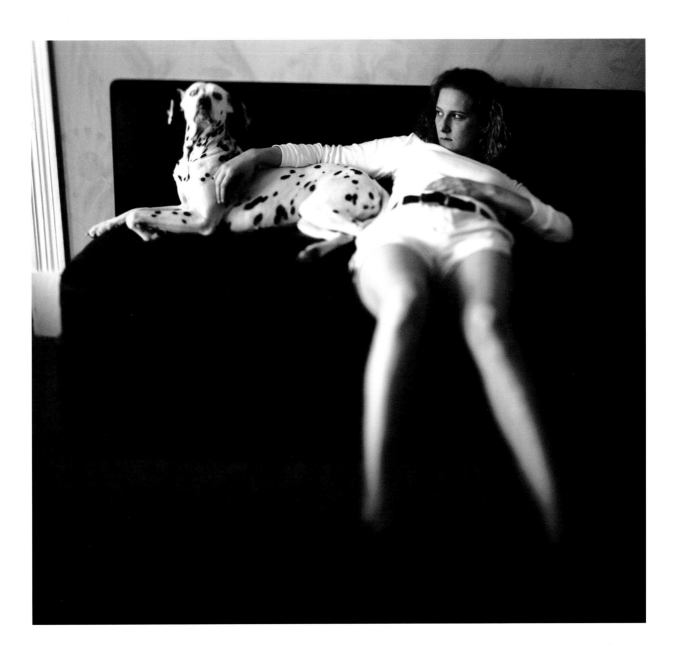

I am concerned with being home,

being attached

being safe

but also about being left vulnerable

to the wild world,

beckoning and demanding my attention.

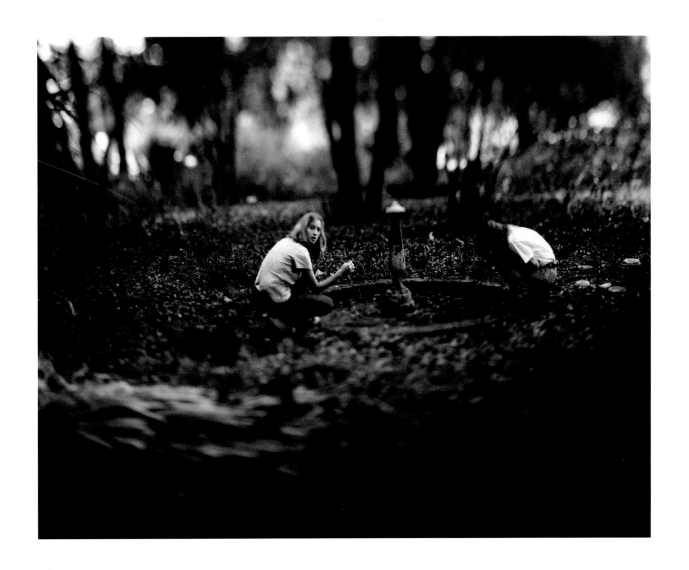

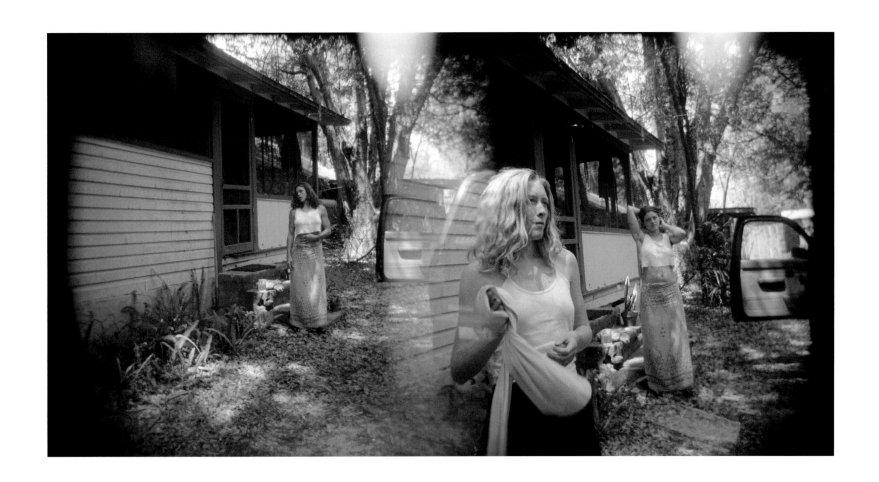

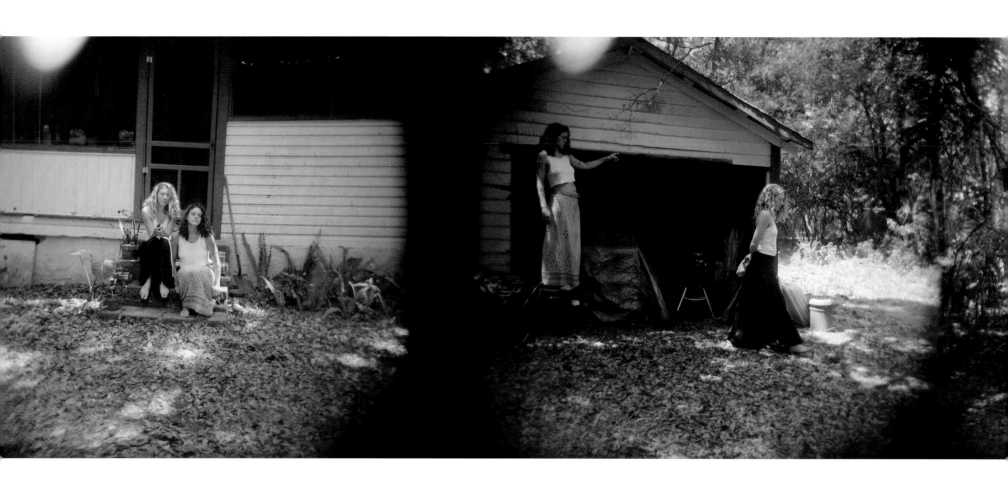

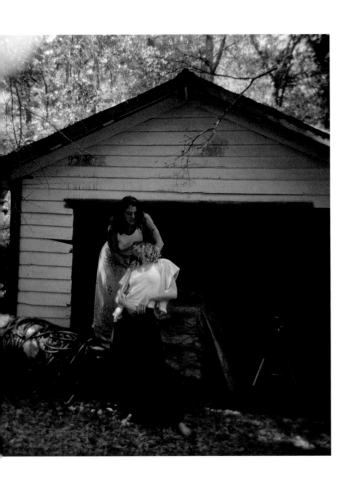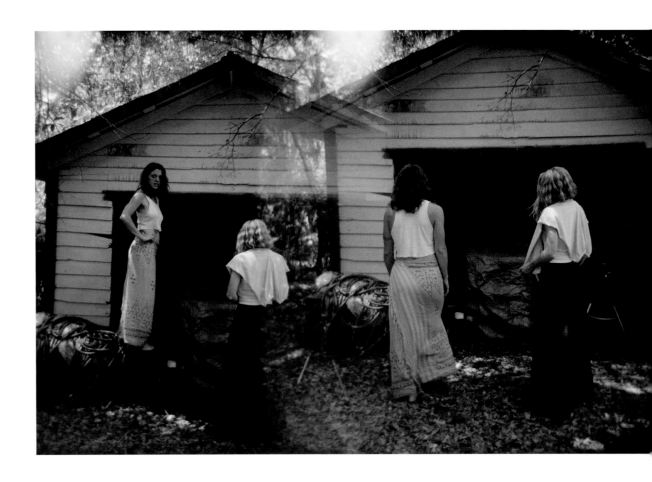

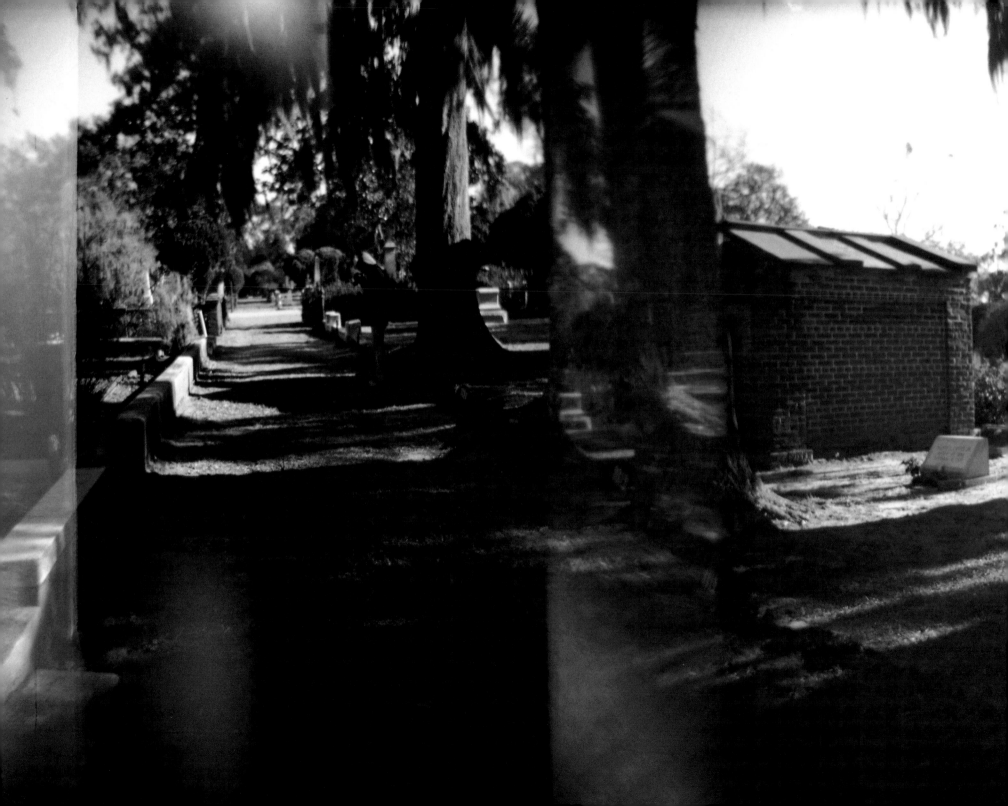

a transitory brightness and piercing darkness

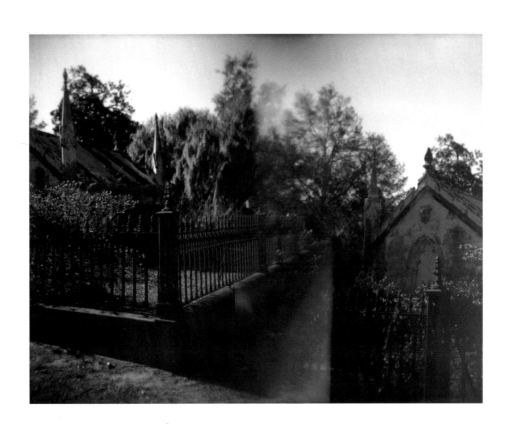

There is no real focal point,

no real measure,

so that it is like a dream or a myth,
a half reality
the reality one's subjectivity creates on its own

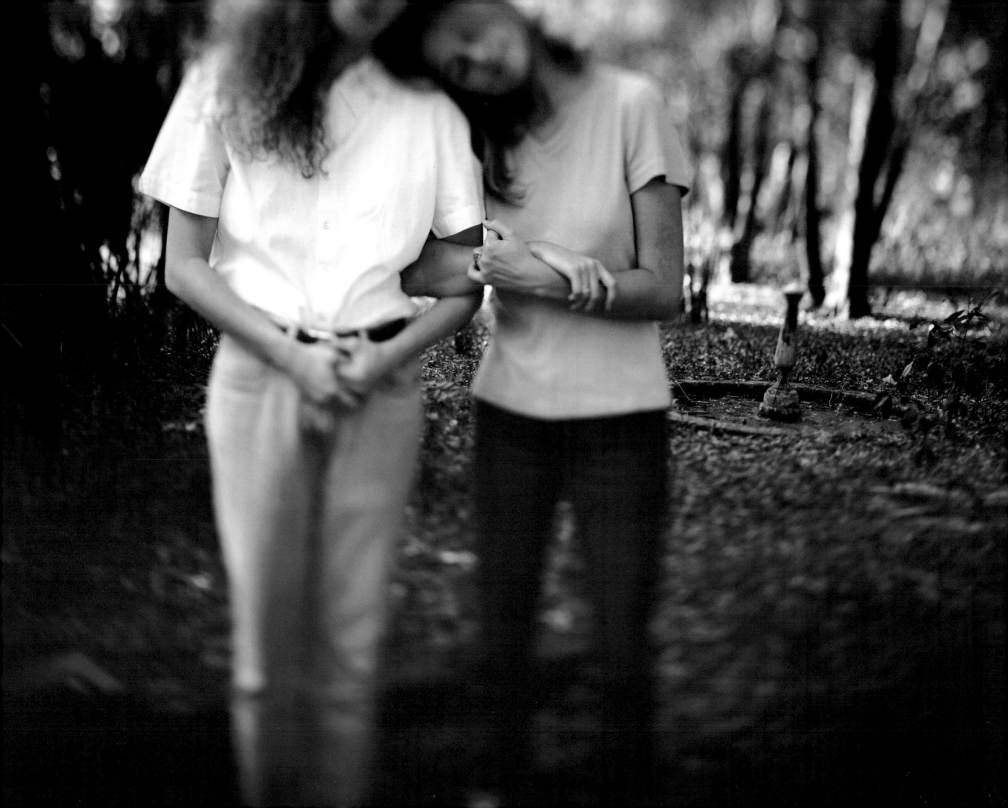

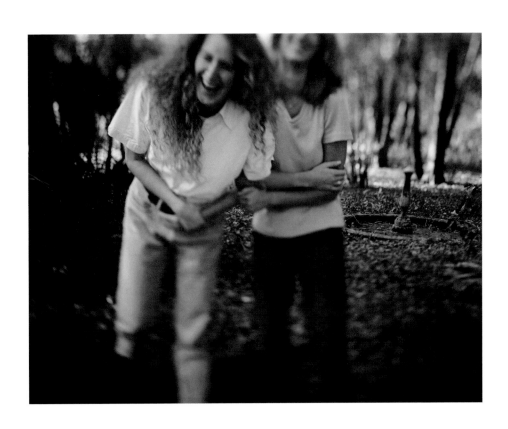

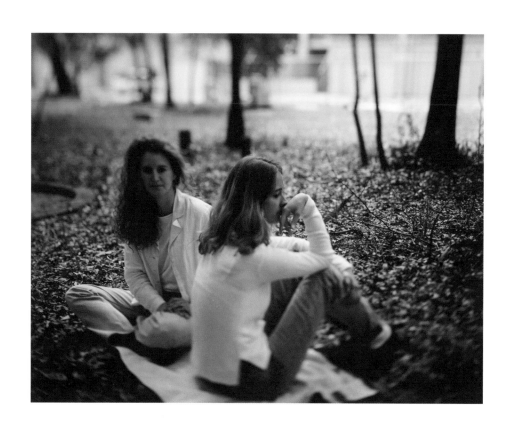

a carefully composed moment

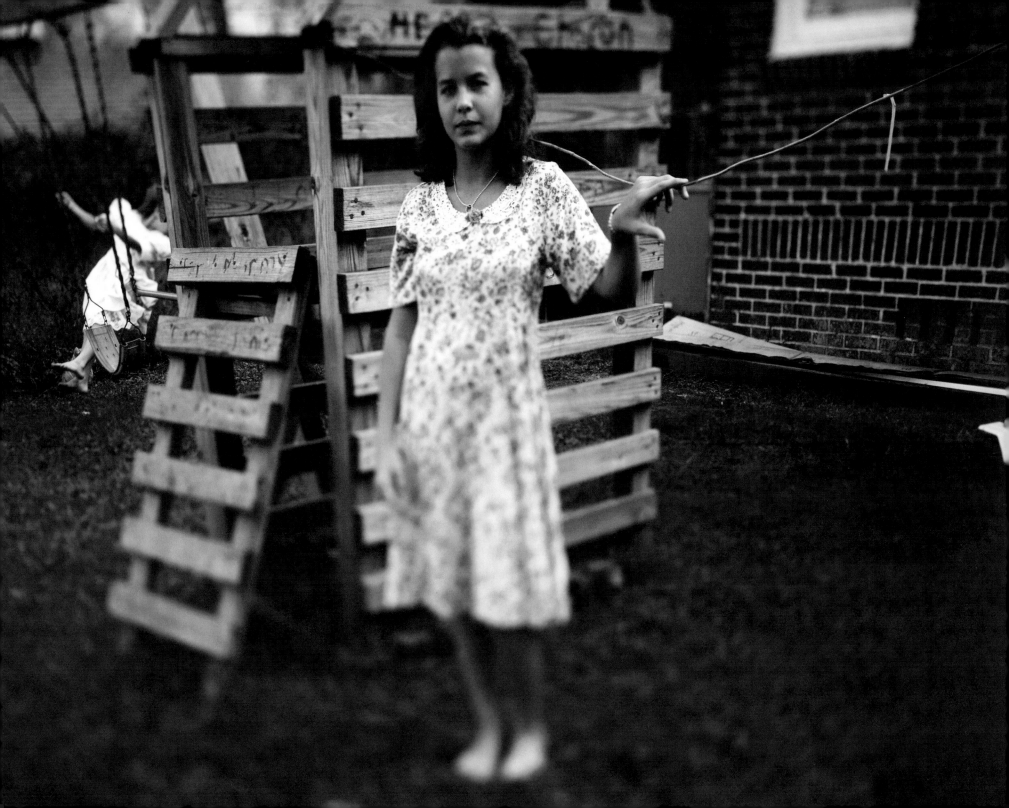

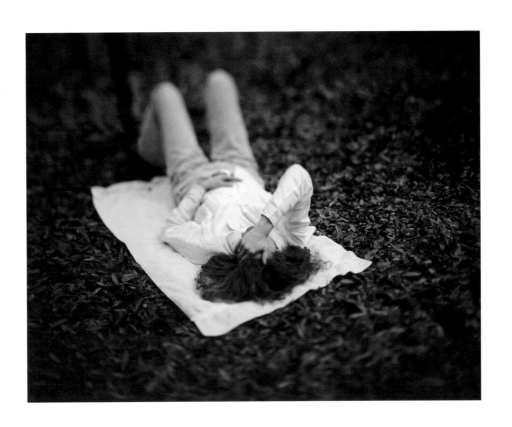

With a quiet and patient presence

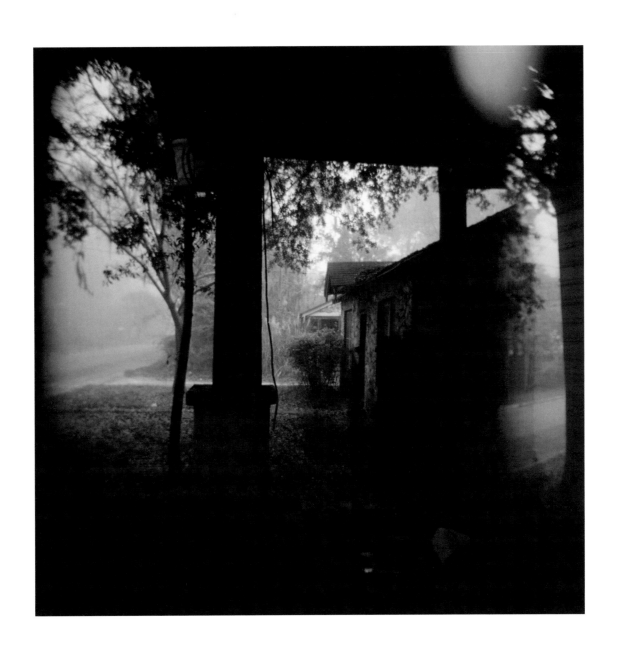

Reminiscences on the life and work of Abigail Cohen

Abigail was a graduate student of mine. I saw her potential develop into a vision that had a unique flavor of its own. Empathetic with her peers, she often included them in her images which featured a transitory brightness and piercing darkness, a metaphor that seems ironically significant in retrospect. She challenged me, she made me think, I miss her.

Steven J. Bliss
Chair, Photography
Savannah College of Art and Design

Abigail approached a photograph as though it were literature, establishing the set and choosing the characters. Her thesis show was a huge success in invention and creativity. She hung a circle of images from the ceiling. The viewer had to step into the space and walk around the inside of the circle to view the work–essentially a short story with no beginning or end. Hence, the circle of life.

Jaclyn Cori
Photography Professor
Savannah College of Art and Design

Such a beautiful, talented woman...I will miss her...I will miss her vision.

Paris F. Carnahan

Abby's work is indicative of her ability to see between and beyond the material world. She was always able to capture a quality about her subjects that somehow revealed their commonalities and humanity. Many of her photographs seem to highlight where body meets and becomes space, causing boundaries between the physical and the metaphysical to blur. With a quiet and patient presence, Abby saw behind facades, and called attention to the essence of situations. In this way, her photographs and her life were intertwined.

Danielle Taylor

Abby was my best friend. I remember when she first started taking photographs and how I loved to be her subject. She made me giggle and told me to be myself. Now that she is gone, that part of me that I shared only with her no longer exists. For twenty years, we shared stories, laughs, arguments, and celebrations. I miss her every day, but my memories of our friendship and the pictures that we took will always keep me company

Ricki Gever

I can remember the day Abigail took this photograph. It was a clear, beautiful, autumn day in Savannah. The three of us, Abigail, Wendy, and I, spent the afternoon together talking and photographing. Abigail casually composed each image through the ground glass of her 4x5 and waited for the perfect moment. This photograph is a symbol of our friendship, for this is a carefully composed moment in all three of our lives.

Danielle Goodyear

Like most of Abby's friends and fellow students at the Savannah College of Art and Design, I had no idea that her young and promising life was in danger of ending as it unexpectedly did in December of 2000. Abby gave no indication of the heavy weight of mortality that hung over her every day. Her spirit and sense of passion transcended her own problems and fears. With the recognition that life was really very simple and straightforward, she explored the wonderment of love and life with grace, honesty and simplicity. She believed that what was most important was not what you accomplished, but how you did it. Photography for Abby was a reaffirmation of her place in the world. Within the circle of her family and friends, there was no beginning and no end. Just the uncomplicated prospect that life would go on.

John Hames

Abby continually explored the mysterious edges that define people's relationship with each other, their surroundings and circumstances. Her ability to relate to every type of people was a tremendous gift.

We schemed our whole lives together.
We were supposed to grow old together.

Dana Sunshine

Abigail, the love of my life, showed me beauty in all its complexity. Her pictures show her essence, the depth that was Abby.

Ed McGowan

A Blessing

Remember us?
Two girls. Twelve years old.
Meeting. Connecting.
Making each other laugh from the very beginning.
Growing up together like sisters
Neither of us had in our brother-saturated families.
Swapping stories and jokes, visions, feelings.
Trading books and opinions about books
And opinions about everything
Trading boyfriends
And always trading opinions of boyfriends

I can't separate my memories of getting to know you from getting to know myself
At each turn of my life you were there turning yourself.
How many people can you think back on their clearest memories of happiness
And find that one single person was there almost all the time?

Your voice- the way you greeted me identically each time I ever called you for
fifteen years-
Echoes when I think of you
Greeting me again
And again
As if you are still here with me.
A blessing.

Carrie Brownstein

What can I say about Abigail? I knew her for only a few years, but was planning on knowing her for so much longer. It was easy to be natural with Abigail. As a photographer, she felt little need for overt control. Using a plastic camera and available light, she isolated moments of timeless simplicity.

Sarah Whiting

Abigail's work had genuine purpose. She worked diligently and never seemed to give up on her dreams. One beautiful fall afternoon, Abigail took photographs of my daughter Kaya and me. She captured Kaya's playfulness and shyness. Those photographs I will cherish forever.

Sandra Mudge

Artist
Scholar
Teacher
Inspirator
Humanitarian
Earth Mother
Sweet Baby
You have forever changed us
You are forever with us —

Kate Kauffman

None of us realized how far Abby traveled in her 27 years. She penetrated the hearts and minds of many. Her photographs, especially of her friends, bring each one of us to our own places of memory.

Julia Pershan

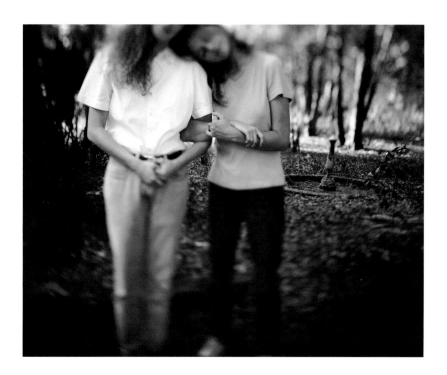

Discussion on Abigail Cohen

January 2002, New York City

Craig Stevens, Joyce Tenneson, Mary Ellen Mark

CS The three of us agree that Abigail Cohen was able to develop her own style. I think it would be interesting for other young photographers if you would each comment on how a signature style develops...

JT Developing a voice of one's own often takes a lifetime - many artists never achieve a distinctive look with their work. Abigail always knew time was precious -she honed in on what was most important to her - her relationships and friends. This gave her work a personal imprint - she wasn't trying to imitate anyone else.

MEM Abigail took a workshop of mine in Mexico in 1997 - it was a great group. She really grew quickly after that - I told her she needed to have a more unique sense of graphics in her work - to organize the whole frame - she really listened to that advice, she was the best student in the class. Abigail told me she had a very supportive intellectual family. She said she felt blessed by them. She never told anyone she had a heart condition - she never looked for sympathy. She was quiet but feisty and determined. She worked very hard.

CS I think Abigail knew she had a limited time on earth.

MEM How did you know?

CS One day she seemed very, very tired - almost struggling. She told me but asked me not to tell others about her condition.

JT Perhaps that is why her work is all about connectedness - which is what helped give her work such a personal thumbprint. Her pictures are about touching - the relationships we have - the gestures of connecting. She photographed the people in her intimate world - people on whom she was emotionally focused.

CS What kind of work did Abigail do in your class?

MEM She did a documentary series on a weaving village and worked on improving her sense of graphics. The fact that she didn't know people in the village allowed her to concentrate on seeing the picture frame as a graphic space - she worked really hard on re-training her eye.

JT Abigail was an intern with me that summer in New York City. She showed me the work she had done before and after Mary Ellen's workshop. The difference was astounding. Something "clicked" in her head about the way to use space in her pictures . . .She was off and running!

MEM Her use of space was not conventional.

JT She had the intelligence to learn from Mary Ellen and to see what her next step was going to be. She came back to Savannah College of Arts master's program determined to document her own community with an off-beat but sophisticated use of space.

MEM Abigail really had an enormous transformation after Oaxaca.
She learned to organize her frames in a unique way - they seem haphazard, but there was a real intelligence behind her new graphic sense.

JT Abigail had a belief in the importance of excellence. She told me she wanted to take

103

what she had learned with Mary Ellen about the complexities of the picture frame and do a series of personal photos of her own circle of friends. Being in Savannah for two years in the Masters degree program gave her the opportunity to complete her first major body of work. The photos have the authentic sense of a young woman discovering her voice in the South - they have a very specific sense of time and place.

MEM Abigail was driven in a healthy way - she wanted to do the best and most honest work she was capable of

CS During her time in Savannah she really managed to evoke the mysteries and the people in it. I felt I got to see them in a new way through her pictures.

JT She came back to my studio just before she finished her master's and brought the new work to show us. We laid it all out on the floor of my studio and my assistants and I were very impressed and moved by this whole body of work. It brought us into Abigail's own world and yet it had a universal feeling as well.

CS The three of us have been looking at work for decades now - what is it about a photograph that can still make us stop in our tracks?

MEM I think it has to do with having an original way of seeing the world. Often when we look at young people's work we sense they are trying to photograph what they "think" makes a good photo.

CS Right.

MEM Every once in a while you see work where a young person has their own point of view already. Abigail was one of those people. I love this photo of her sitting at the table - you see her honesty. A boy from our class took it.

104

CS I think she was one of the most sincere people I've met.

MEM I love this picture - It's so real and beautiful.

CS Let's get back to the question of what makes a photo stop you in your tracks . . .

JT I agree with Mary Ellen - I love to see a photographer with their own unique point of view - something you sense is coming from a deep place, a heartfelt place, their authentic self. Abigail's work really seems like a self-portrait. Through her photographs I see a young woman coming into her own, as both a person and a photographer. That's touching and interesting to me emotionally and visually.

CS What makes an image hold me is something that is not only a document, but an image that enters my own imagination and resonates in a new way.

MEM I think Abigail realized in Mexico that she would not be a photojournalist. She knew she didn't have the stamina to be a documentarian - out on the streets and traveling to remote areas . . . I think she decided to do what she knew she could document best - her own circle of life.

JT When I first met Abigail, she was searching for that passion. When she got to Savannah and had the encouragement of the photo department here, it gave her the confidence to go with her deeper instinct. She didn't look back.

105

CS We encourage all of our students to do work that has a real meaning to them personally.

JT She realized she didn't have to go somewhere exotic like Bali to be a true documentari-an. She realized that documenting the intimate symbolic life of a young woman was its own

kind of documentary. It could stand as a metaphor for all young women searching for themselves.

CS Yes, she developed an incredibly sophisticated vision over that two-year period that will speak to and move many people. I think we all feel enriched by her vision.

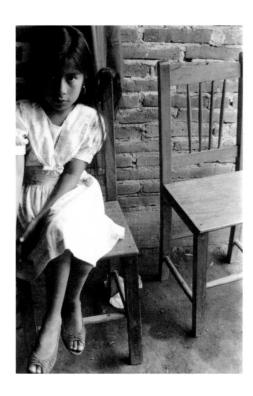

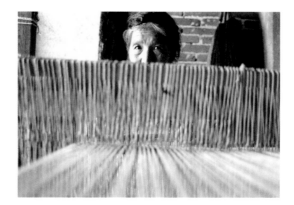

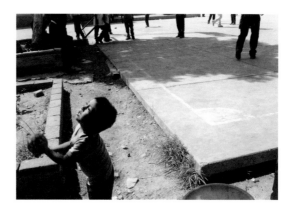

Mary Ellen Mark

Mary Ellen Mark has received international acclaim for her documentary photography, gaining worldwide visibility through her numerous books, exhibitions, and editorial work. Mark's photo-essays are featured in publications such as Life, the New York Times Magazine, New Yorker, Rolling Stone, Vogue, and The London Sunday Times Magazine. She is currently working on her most recent project, *Mary Ellen Mark: American Odyssey*, a book and traveling exhibition, featuring her photographs from the United States, taken over the past 35 years.

Joyce Tenneson

Joyce Tenneson was voted by American Photo Magazine as one of the most influential women photographers in the history of photography. Her personal work has been shown in over 150 exhibitions worldwide and is included in numerous museums and private collections. Tenneson's photographs appear regularly in many major magazines, including Time, Esquire, the New York Times Magazine, O Magazine and Entertainment Weekly. Tenneson is also a respected lecturer and teacher. She currently lives and works in New York City, and recently released her seventh book, *Wise Women: A Celebration of Their Insights, Courage, and Beauty*, featuring exquisite portraits and quotes from women 65 years and older.

Craig Stevens

Craig Stevens is a revered Professor of Photography at the Savannah College of Art and Design in Georgia and on the faculty of the Maine Photographic Workshops and the Santa Fe Workshops. He has lectured across the country and his work is widely published and exhibited. Steven's photographs are in collections at the Foundation of Vincent Van Gogh in Arles, France, the Museum of the Art Institute of Chicago, the Library of Congress and many others.

AFTERWORD
By Betsy Cohen (Abigail's Mother)

Abigail's photographs and photography were really a metaphor for her life. What is really the picture?, she always mused, is it my vision of what I'm photographing or my subject's vision of me doing the photograph? Both, she'd inevitably conclude. Standing back just a little, she gave her subjects broad range of self-expression while being acutely conscious of how her vision of them impacted the final photograph. The interaction was the essence for her.

And so it was with her friends and family. Her own centeredness - wrapped, of course, in an appropriate layer of insecurity - provided some ballast for those around her. She believed in all of us - even while seeing us in a very clear way. She knew what you should be doing and, even if you resisted at first, you found yourself listening and then wanting to know more. "What will I do next year," asked a close friend after Abigail died, "if she is not here to tell me?" Her fierce caring is reflected in her photographs - the desire to tell your story, as she knew you wanted to tell it, through her vocabulary of light and place.

Her family she was stuck with - although I think she liked most of us most of the time. Older brothers are not easy, but she was in awe of Daniel and laughed heartily and wickedly with Jonathan. As for sisters-in-law, she admired Suzanne's sense of style and forged intimate ties with Julia. Her father was both a source of wisdom and amusement, her grandparents, an ever-present safety net. But her adoration was reserved for Solomon and Emmy, her nephew and niece, with whom she played and whom she taught, for she was a born teacher.

Abigail was 27 when she died of a congenital heart condition. She'd defied it for years during which medical science was on her side. She demanded a full life - yielding only by not going on a photographic assignment in northern Uganda - and she lived it. Travel to South America, Mexico, Europe, and Asia was interspersed with her plans for fellow artists: a retreat in Montana was an early dream, the actual founding of her own business, The Art Biz.com, a later accomplishment. The Art Biz was born of a desire to help artists manage their lives efficiently and knowledgeably so that they might more fully concentrate their energies on creating art. This was an enterprise enhanced by the opportunity to work with two close friends who shared her vision and who carry it on - Dana Sunshine- who Abigail knew since childhood -and Danielle Taylor- who Abigail felt like she knew since childhood.

Friendships and relationships were a passion for Abigail, and that passion is reflected in this book. *One Cycle of My Journey* includes images of Casey Sayre, a college friend, and her sister Becca, in photographic sequences that reflect their togetherness and apartness; Ricki Eisenstein, a friend from age 12, carrying her young son Eli; and a single mother Abigail had recently met whose aloneness she managed, typically, to capture completely among others.

I also want to mention two others. Beside Abigail over the last five years was her soul-mate Ed McGowan, whose unconditional love gave her the confidence to take bolder steps. And giving her creative insight was Kate Kauffman, whose loving portrait of Abigail - our favorite - appears on the jacket. Of course, there are so many others so important to Abigail. Their love and support provided me with a cushion for my loss. Abigail was so vibrant a part of my life - whether asking me to find her keys which she lost at least once a week in a variety of cities, or sharing a success, or just laughing about something from her somewhat quirky point of view (she had a great laugh, between a cackle and a giggle) - she was always there. My pride in her legacy of insightful images with which we filled this book is immeasurable.

But the catalytic force of this volume has been Joyce Tenneson, who took my fledgling desires to assuage my pain at Abigail's death, coupled with my determination to share the gift of her photographic vision, and channeled them into this project. She understood as an artist, a mother, and a friend. Joyce encourages young talents who grow to share with others; Abigail was one of these young talents, and she learned through Joyce's example how to implement her artistic cravings. Thank you also to Meredith Marlay and Michael Goesele, and Miwa Nishio who, although they met Abigail only through her photographs, crafted this book with determination and love. Michael's sure graphic sense identified the pulse of the pictures and translated them elegantly into a format that is true to and enhances the work; Meredith provided the strong organizing hand and the creative input of a fellow professional and sympathetic photographer. And Miwa transformed the nascent images into a finished product of quality and integrity. Without them, *One Cycle of My Journey* would not exist.

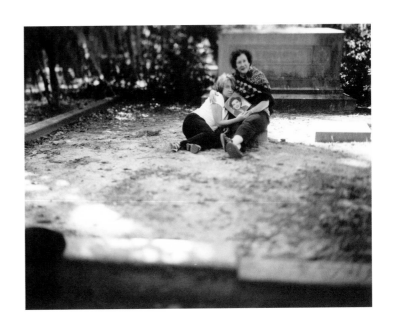

LIST OF PLATES
